ONE DAY YOUNG

Book One
I've Lived in East London for 86½ Years

Book Two
East London Swimmers

Book Three
A Portrait of Hackney

Book Four
Shoreditch Wild Life

Book Five
One Day Young

To order books, collector's editions and signed prints please go to:
www.hoxtonminipress.com

ONE DAY YOUNG

by Jenny Lewis

HOXTON MINI PRESS

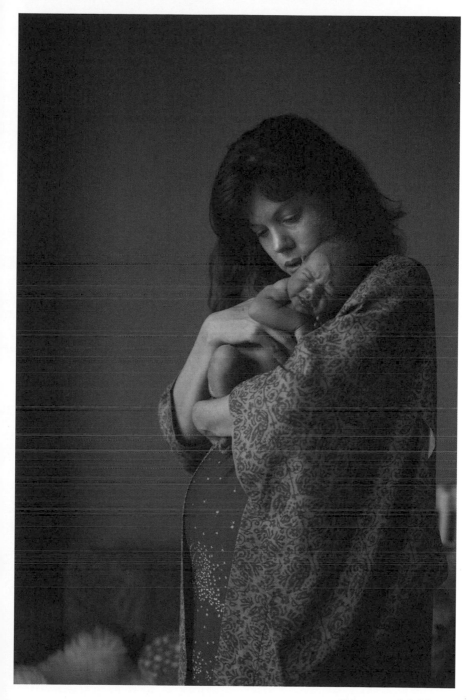

Rebecca and Osiris

FOREWORD

It's really quite simple — I wanted to tell a story about the strength and resilience of women post-childbirth that I feel goes largely unacknowledged in today's world. To reassure women that childbirth is ok; yes there's pain but a positive pain, one that has purpose and is just part of the journey, a rite of passage into motherhood. To make visible other emotions that are far more powerful: the joy, the overwhelming love and the triumphant victory every new mother feels. In my mind this is the supportive message we should be passing on to future generations rather than paralysing them with fear.

Very early on in the project I knew I wanted to concentrate on the first twenty-four hours, when a woman's body is engulfed by hormones, to capture the unrelenting physicality of the moment, straight from the battlefield. Sweat still glistening on the mothers' skin, the translucent umbilical cord freshly severed, and wide-eyed wonder as the women come to terms with the magnitude of what they have achieved and survived.

I leafleted Hackney, the borough where I live, to find my recruits. I did not want to cast people on looks, age, race or class — but to include all who responded. As the series developed over the past five years, the mantra of calm running through the images was impossible to ignore. I find the collection of images quite defiant and beautiful, challenging the expected vision of those first twenty-four hours, a pure celebration of what it means to be a mother.

Dedicated to Ruby and Herb who started me on this journey.

Jenny Lewis

INTRODUCTION

The distinctive, tightly woven configuration of mother and baby endures from every civilisation that has left a visual trace of itself. Since its ancient beginnings an immeasurable mass of ink and powder, sable, glass, salted paper and albumen, silver gelatin and, latterly, pixels has been enlisted to its cause.

As an idea, 'mother and child' only really emerged from the skirts of the Madonna in the late nineteenth century, when artists like Mary Cassatt and photographers like Julia Margaret Cameron, encouraged by romantic Victorian attitudes to motherhood, turned a theme laden with formal convention and religious association into a reflection of happy intimacy. Cassatt concentrated almost exclusively on the subject for the last 25 years of her life, producing around 130 portrayals of a mother's nurturing embrace. The subject so enchanted Cameron that she photographed her circle of models in mother and child pose no fewer than 63 times in the eight years between 1864 and 1872.

Despite its familiarity, the subject remains as emotive as ever. Primitive, insistently corporeal, mysterious — even today in our emotionally sluggish, medically advantaged times, viewers respond instinctively before they do rationally. These kinds of images nudge the limbic system into a fierce emotional register, as likely to make a throat prickle and ache as the corners of a mouth twitch ear-ward.

Jenny looks intently and with feeling at this commonplace and yet most precious of life events. Some 2000 babies are born every day in the United Kingdom, and yet the glimpse she offers, into the beating heart of family life when it is only just beginning, is rarely made public.

These are mothers at the very start of their journey into parenthood. We might imagine them timid, tired and anxious, and they may yet be all of those things, but in these first twenty-four hours, flooded with the potent mix of endorphins and hormones that attend the birth of a child, the women are only steady and forthright, holding their ground. They are hovering at a magic and ambiguous crossing-point between before and after, and the impression this

leaves on the way they look rinses bright through every image.

The mothers are pictured in their own, very personal environments, offering clues — should we wish to look — to their lives and loves. The stillness of the interiors coupled with Jenny's modulated palette radiates a deeply seductive calm that calls to mind the great painters Vermeer, de Hooch, and Hammershoi.

But try as we might, it's difficult to tear our eyes away from the baby, a peculiarity Jenny also found common to every woman she photographed for this series. 'Most of them only manage to pull their gaze away for a few seconds,' she says. 'They're primitive animals at that point. That body language, to a photographer used to spending ages trying to make the subject feel relaxed, be themselves, get rid of their idea about how they want to be portrayed, it's fascinating. At this moment, like no other moment, they are so flooded with their self, but an egoless self — it's beautiful.'

Jenny's achievement is to photograph something incredibly intimate, but without ever exposing or invading. It's a tiny sliver of someone's life — we will never know what has gone before, or what comes afterwards. There might be sad endings as well as happy ones and as much loss as gain, but in that split second the photographs were taken, these silent threads of lives and stories were only just beginning.

What we are left with is splayed hands and curled feet, strong arms and inclined heads, an exquisite study of line and shape, skin and fabric that echoes rhythmically from child to mother to child and back again, in an ancient, complex language. Seen one after the other, the images perform a rich visual chorus, intertwining story and colour and light in such a way that it is impossible not to be drawn in. 'While you live / Relentlessly she understands you' wrote the poet Phyllis McGinley about maternal empathy, and looking at these women knotted snug to their red-raw babies, we understand not just how but why.

Lucy Davies

As soon as I saw him, I was like, 'Oh it's you. Hi'.
He was so familiar.

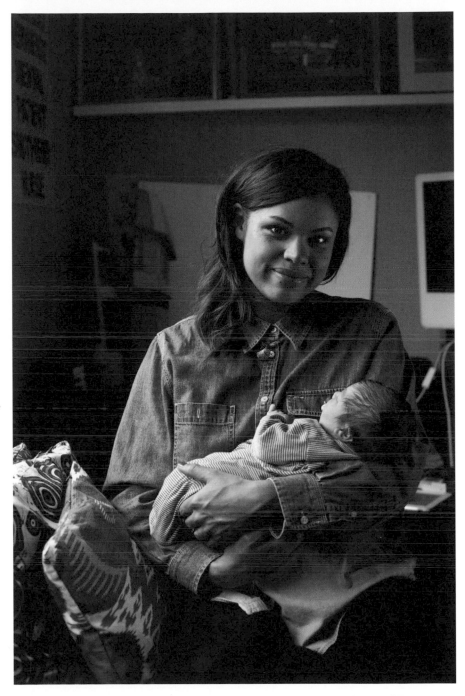

Kim and Perseus

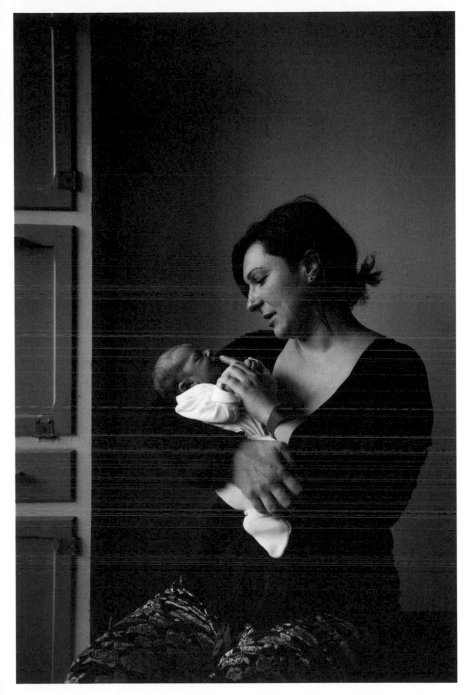

Olivera and Albie

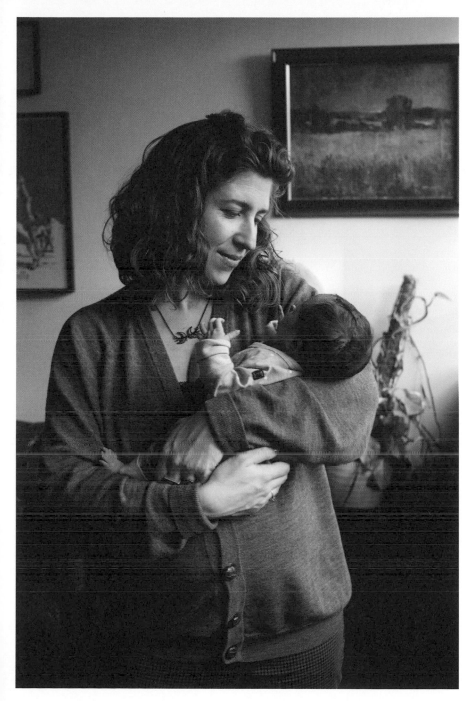

Trini and Carmen

I have never really shared any of these memories,
as if I am a little bit ashamed of how easy and positive
my experience was. How silly is that.

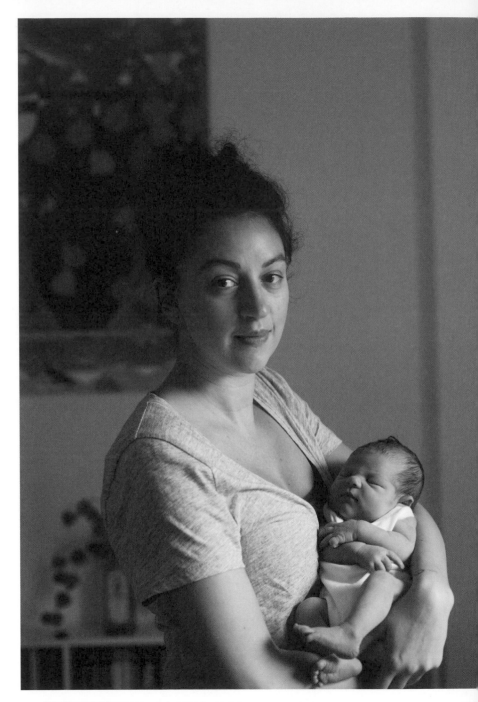

Bertie and Alma

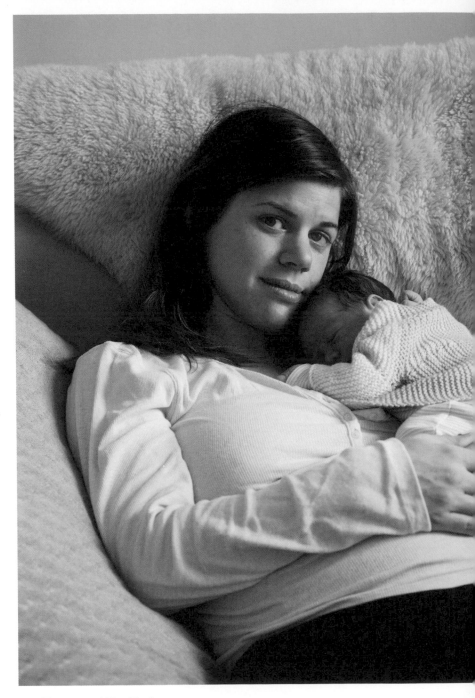

Tamsyn and Eve-Marie

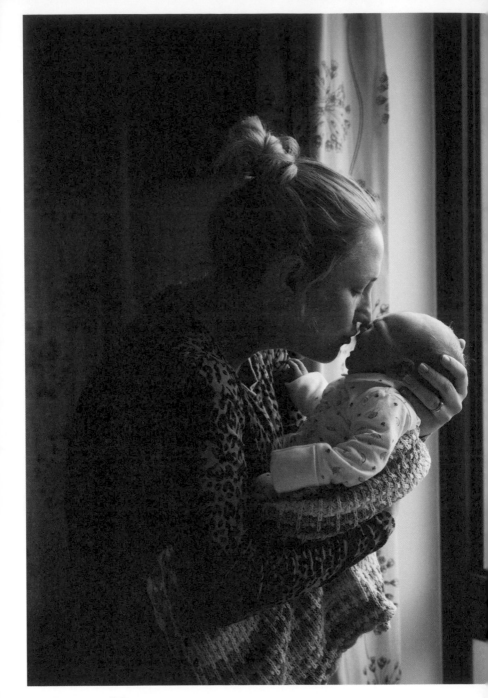

Theresa and Thomas

You just want the world to stand still,
in a way that you've never felt before.

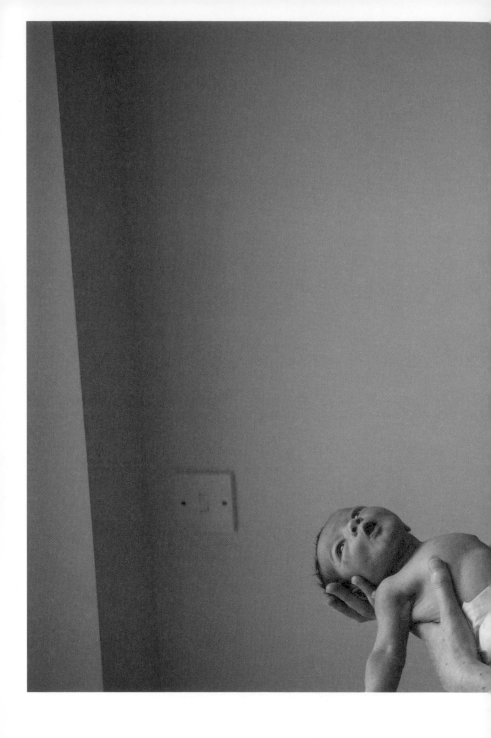

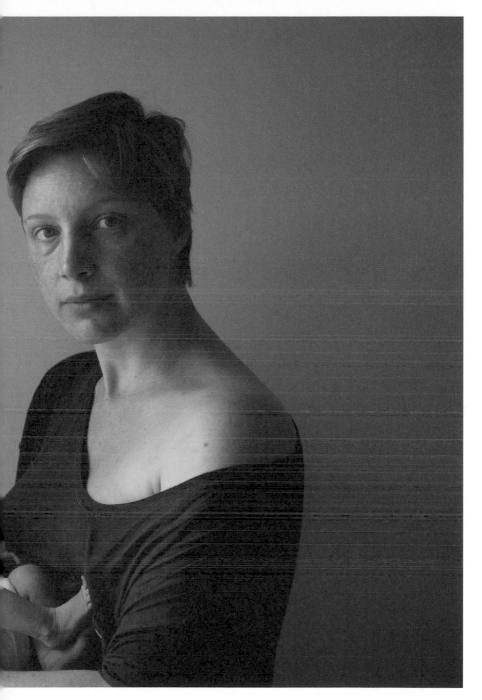

Karla and River

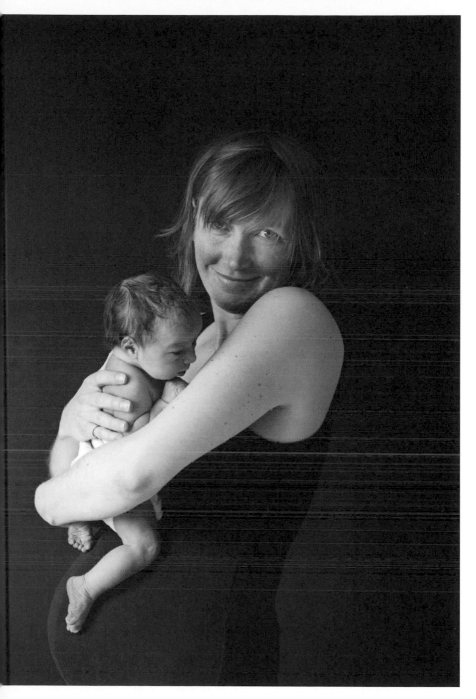

Meredith and Lina

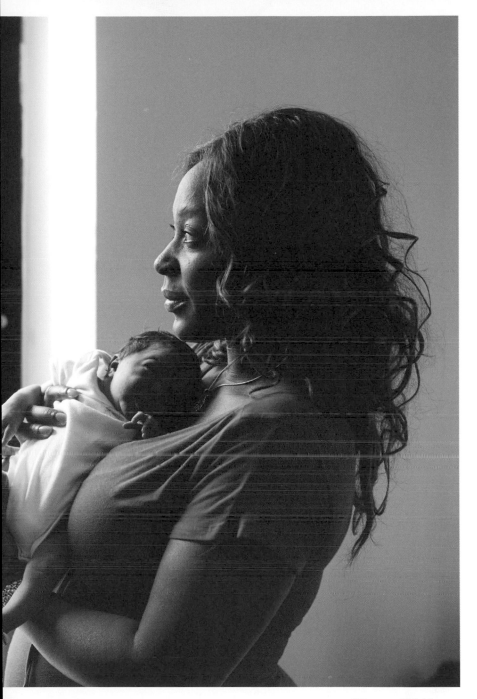

Idoya and Nahia

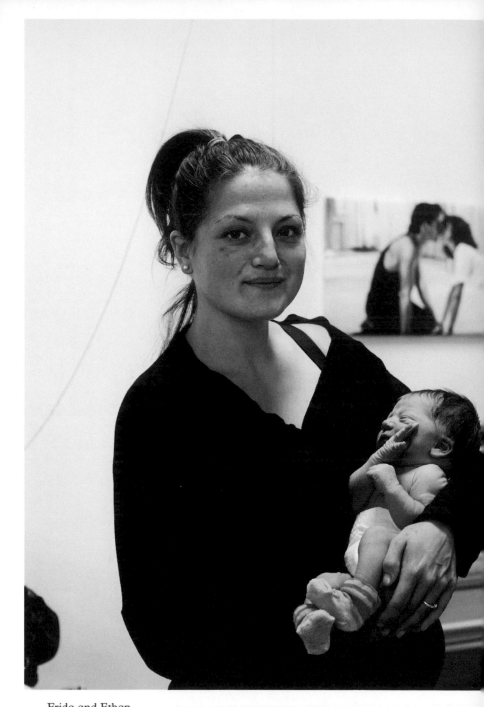

Frida and Ethan

It was just like a friend of mine said,
it's like being born again yourself.
You are seeing everything for the first time.
That's what I felt. Nothing's the same.

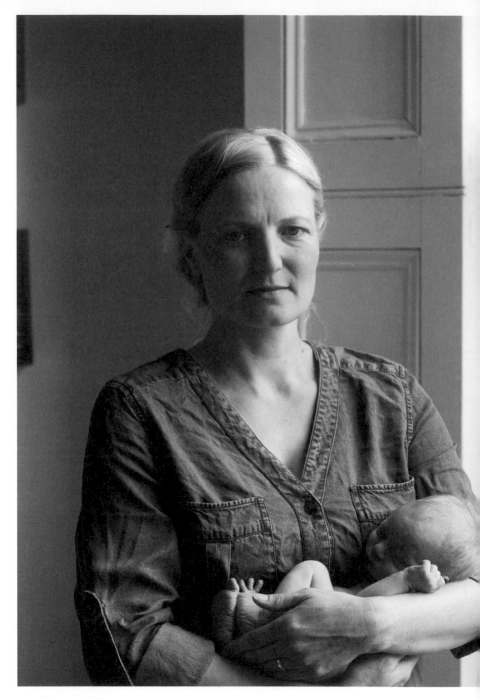

Gitta and Til

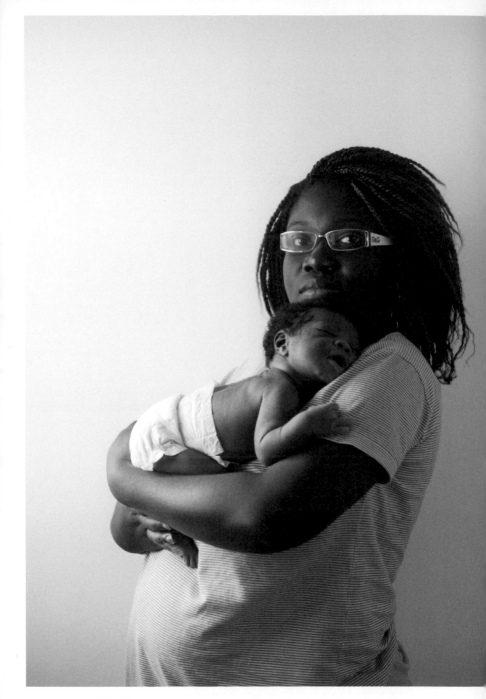

Laure and Tyrick

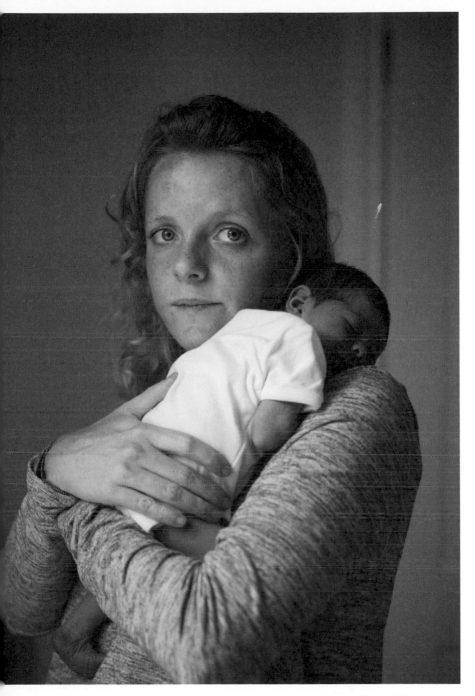

Clementine and Imogen

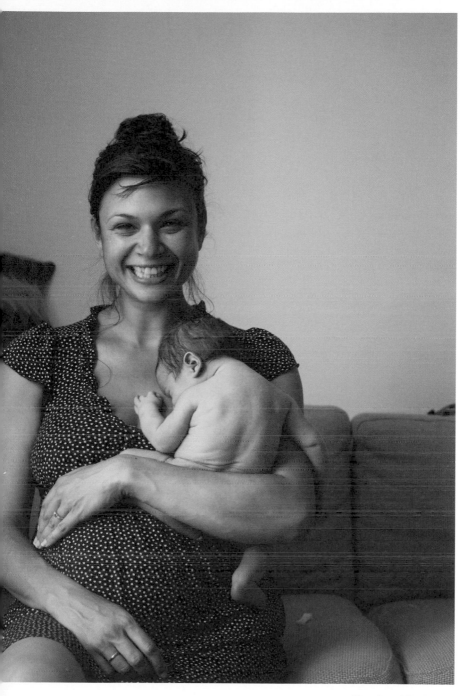

Hazel and Rudy

You feel all this love from everybody around you,
and often you haven't experienced that before,
so it can be incredibly overwhelming.

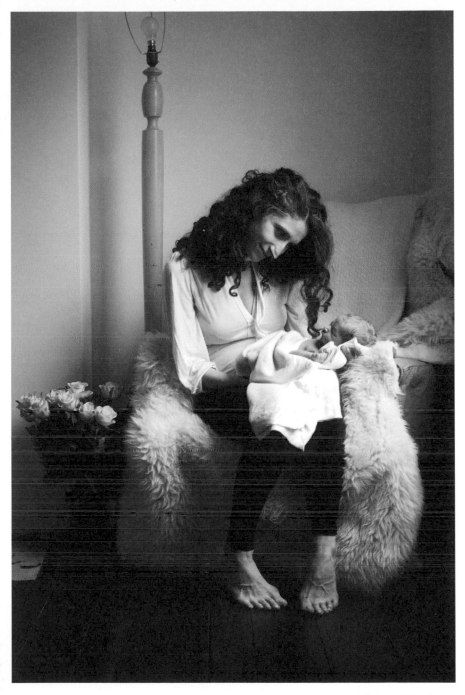

Dilek and Noah

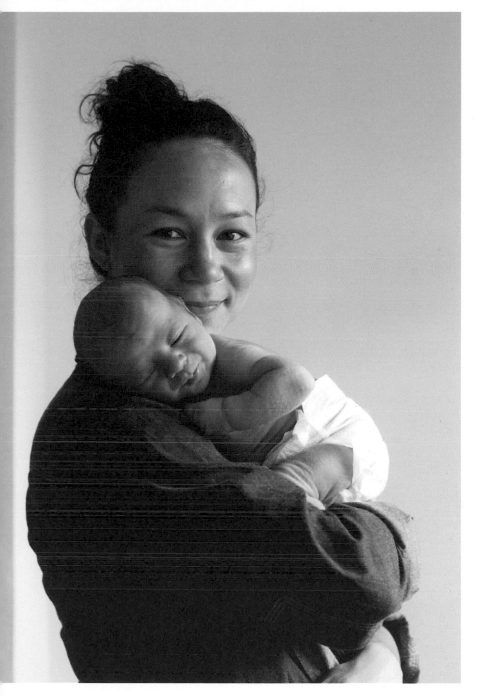

Helen and Hudson

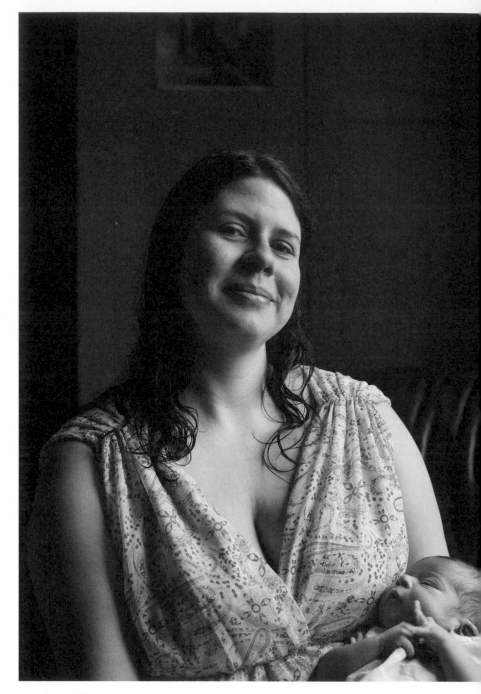

Rut and Jonian

How lucky we felt to have Kiran after losing Josef. Of course there's been lots of grief and anxiety along the way, but new life just can't help but assert its healing presence somehow.

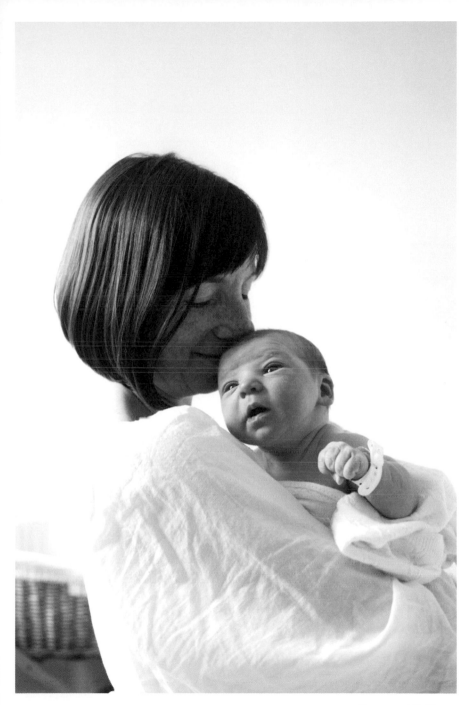

Jenny and Suki

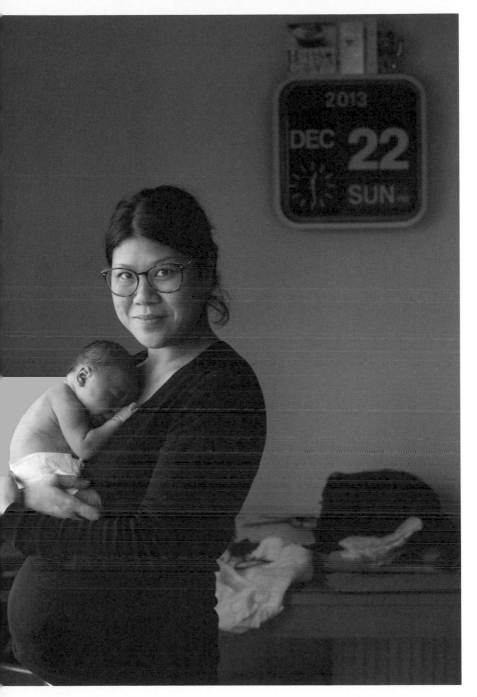

Leanh and Lachlan

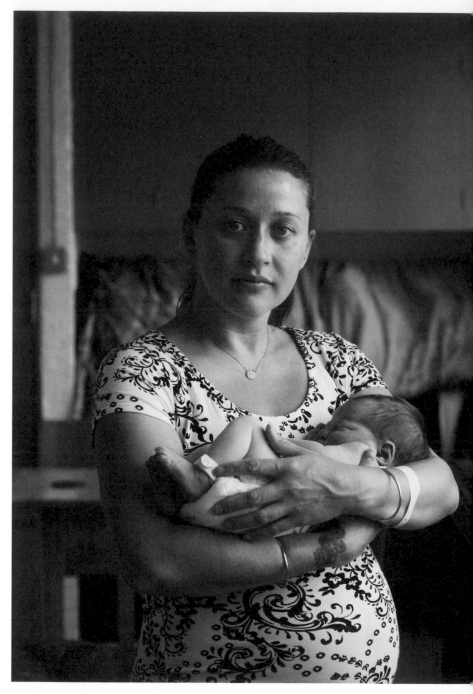

Ana and Barney

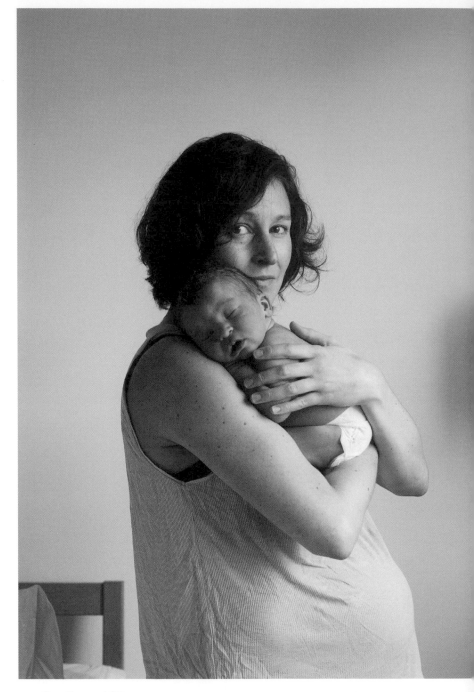

Caroline and Silas

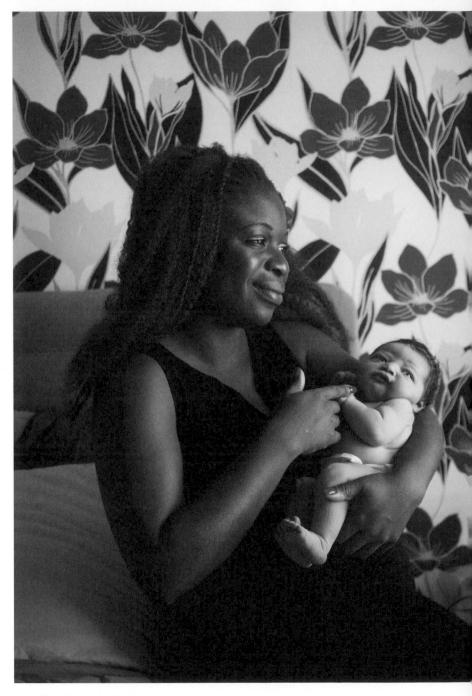

Shenelle and Arissa

My waters never broke so he came out inside
an intact amniotic sac. I had a water birth,
so he was floating peacefully inside a balloon
under water — it was beautiful.

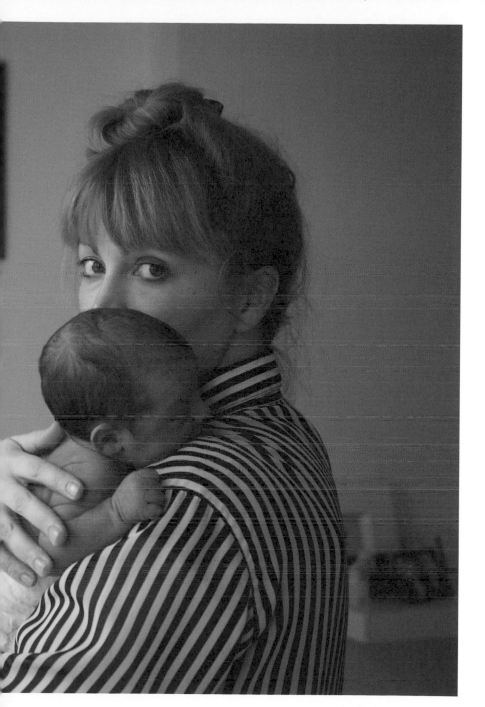

Katharina and Tito

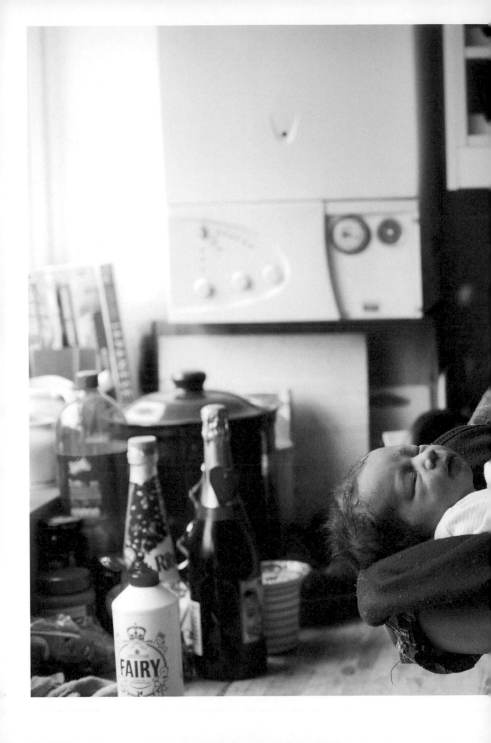

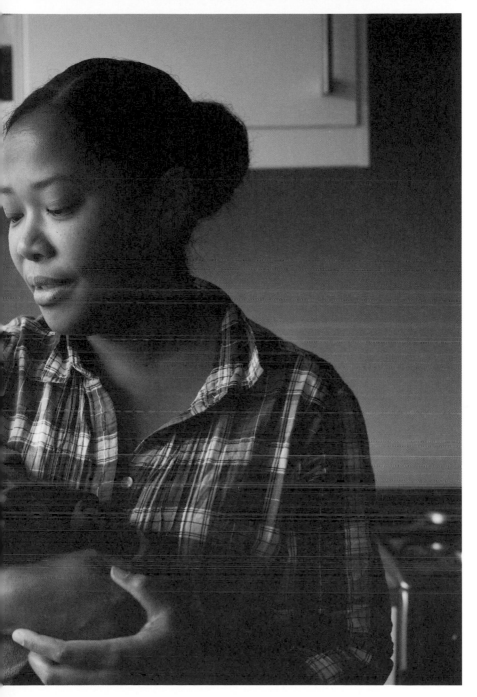

Chieska and Floyd

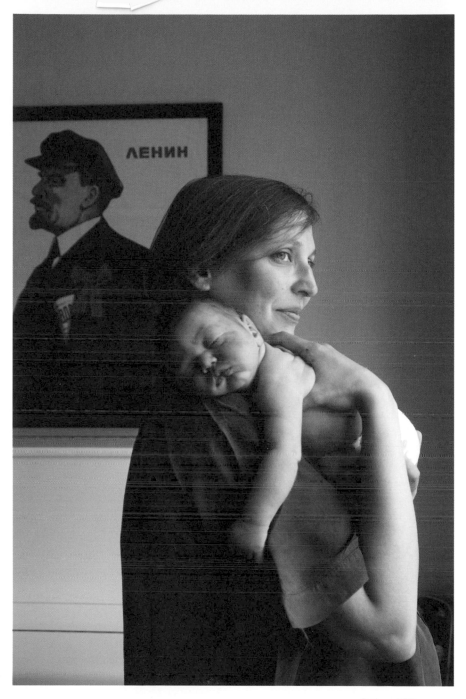

Joti and Kiran

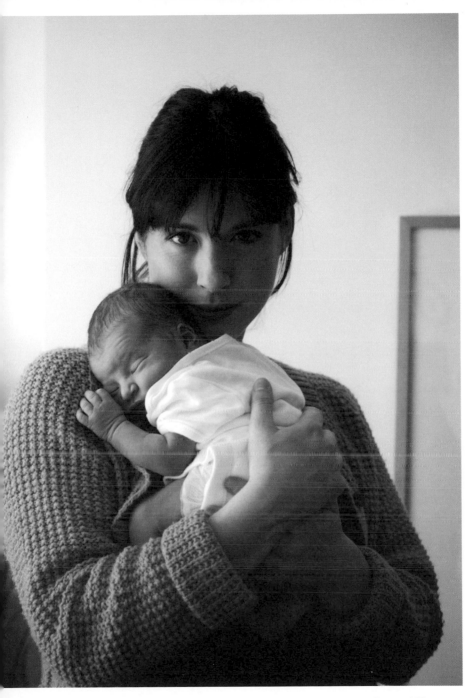

Jen and Nora

You do what you want, when you want... Then it all alters.
All you want, is for them. Anything, everything, is for them.
And with that comes the realisation that that is how
your parents have always felt about you...

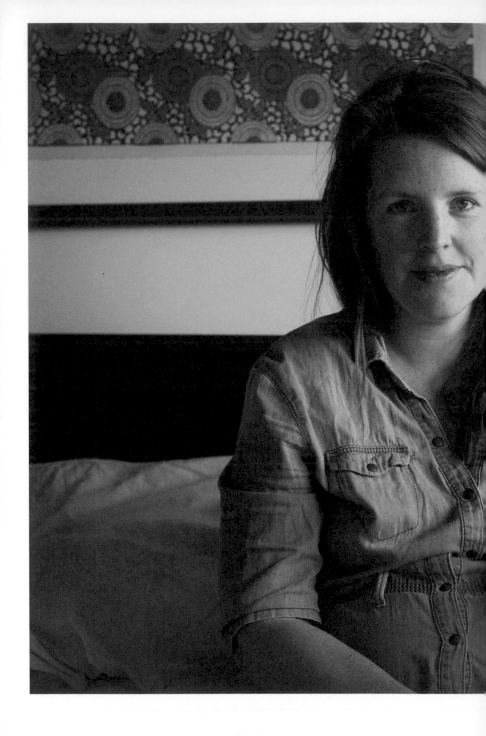

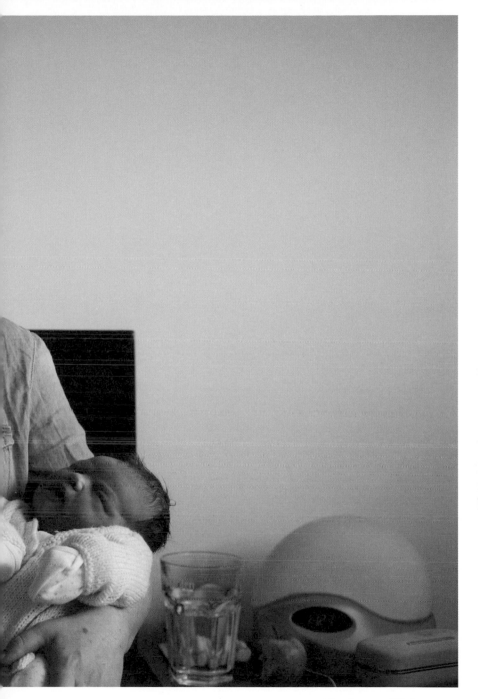

Charlotte and Vivienne

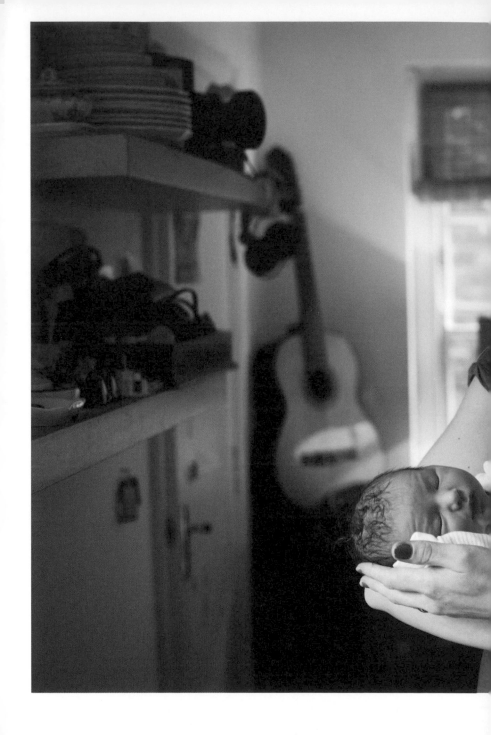

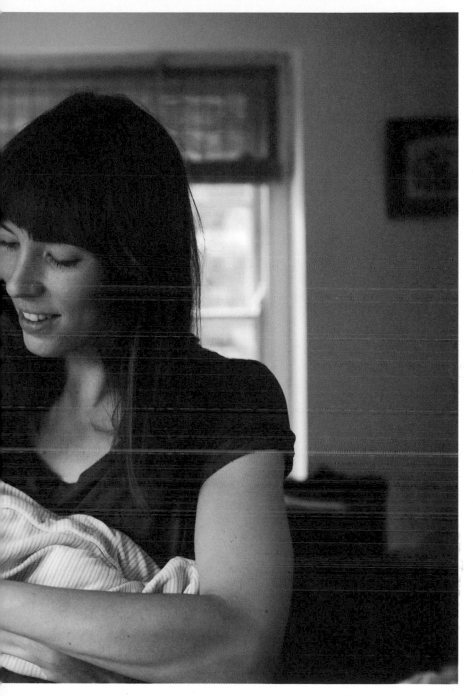

Tara and Penelope

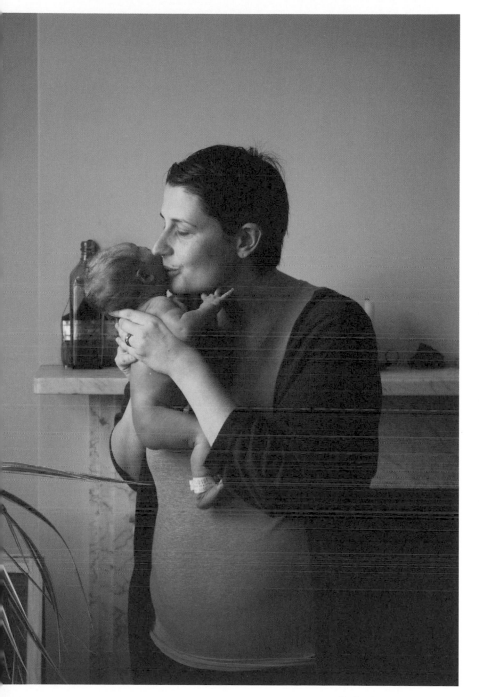

Catherine and Raya

That first night with a newborn is so insane, so precious. It's dark and quiet, the exhaustion kicks in but you cannot help feeling giddy, excited, so incredibly lucky.

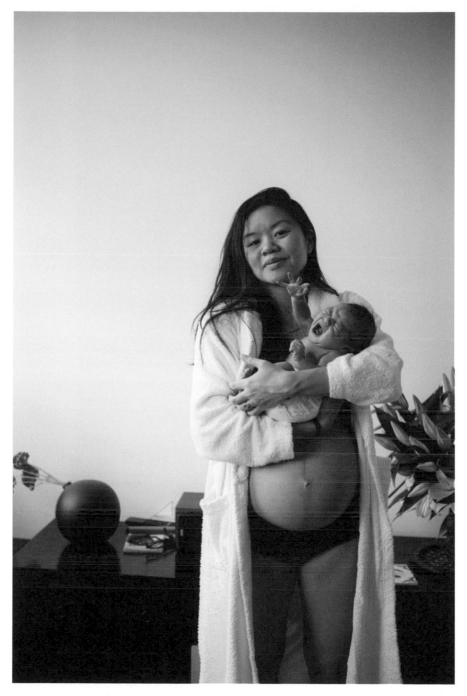

Liana and Archer

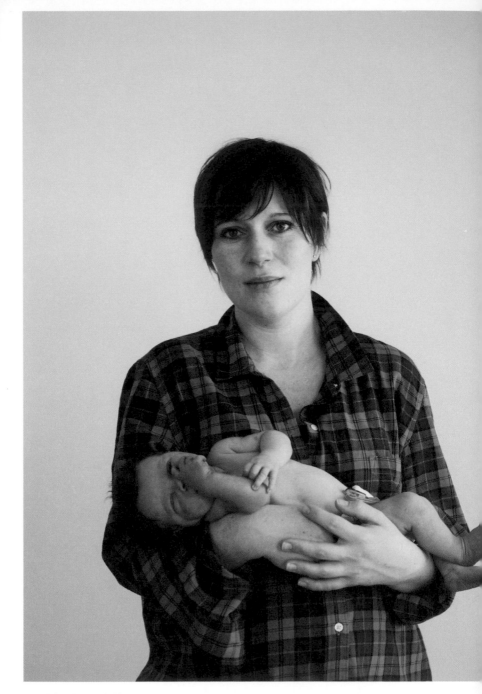

Martha and Clem

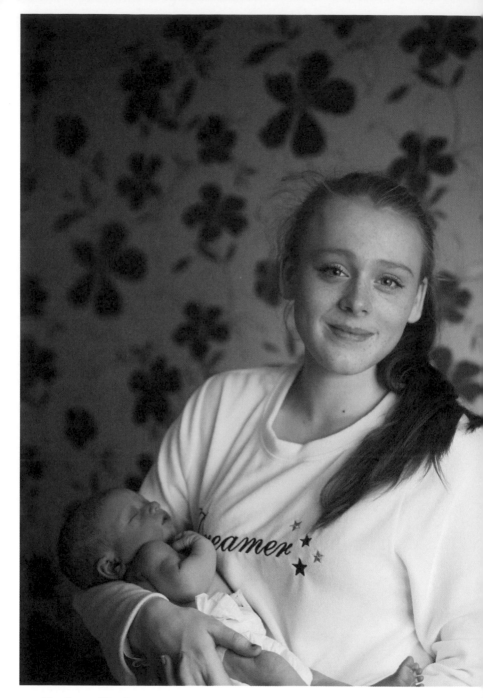

Xanthe and Louie

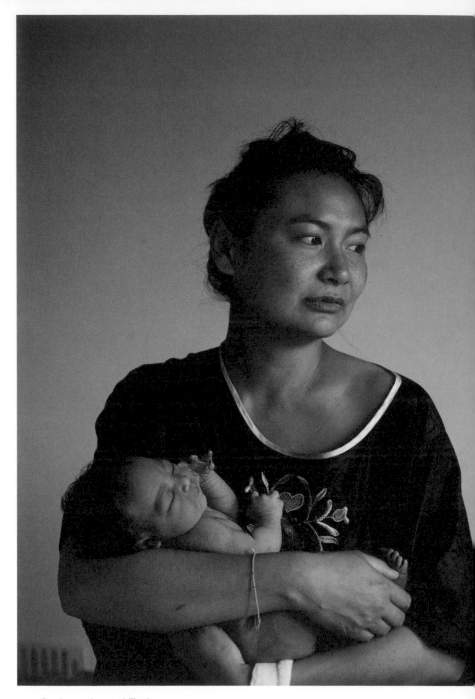

Suphawadee and Evelyn

For someone who is essentially scared of most things
(spiders, moths, heights, mess) I wasn't scared.
Hormones I think.

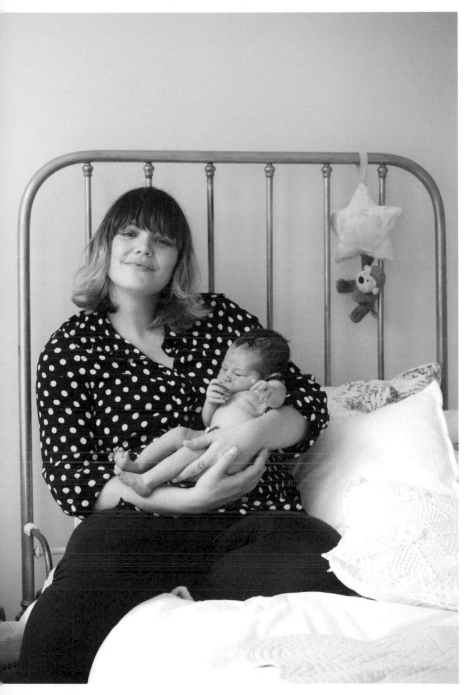

Mairead and Arlo

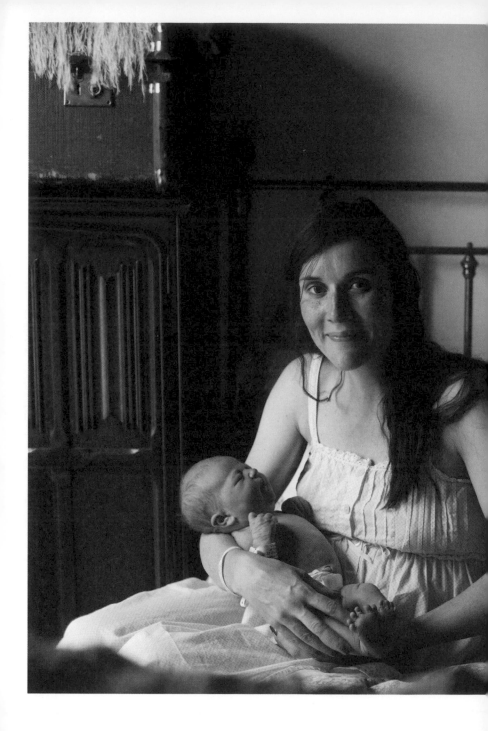

Lu and Bloom

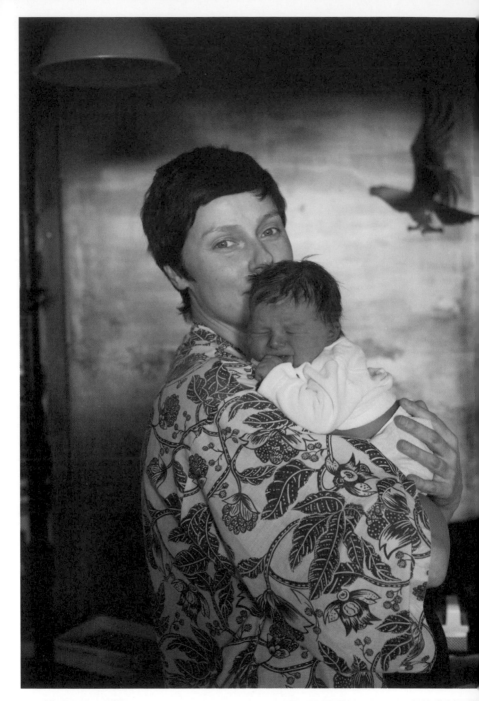

Mairead and Fia

I don't remember how I felt about myself, I don't think I did.
I think I surrendered myself to being totally in love.

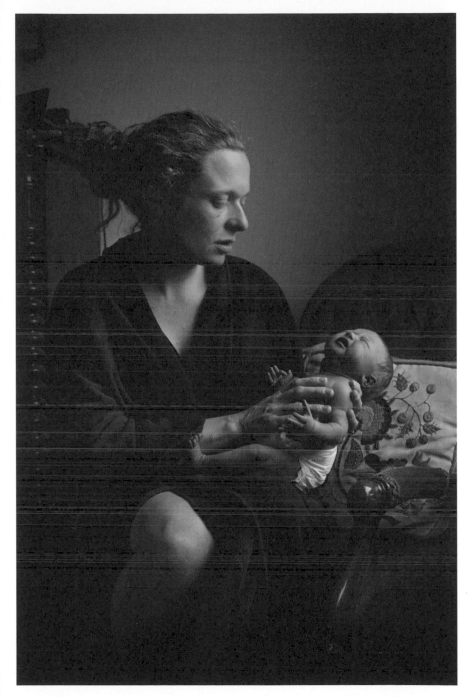

Nicola and Jemima

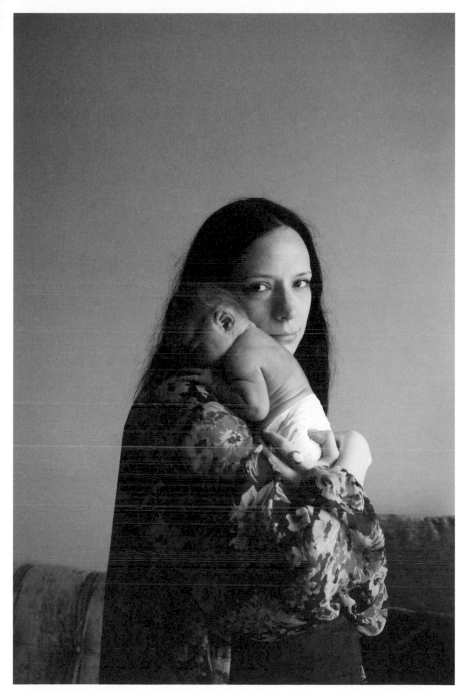

Kyle and Winona

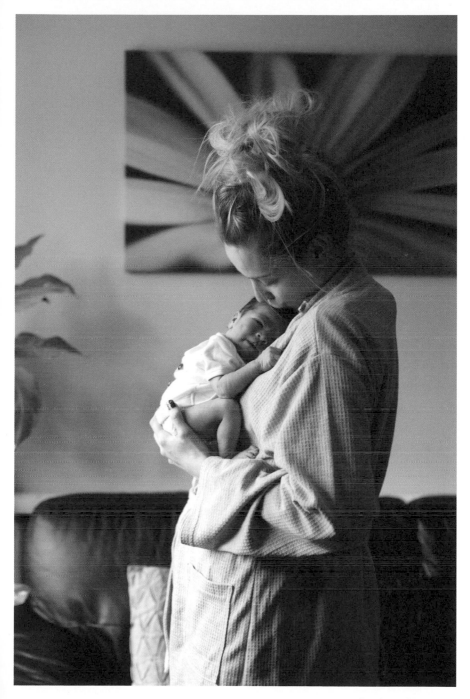

Cassie and Levi

I honestly think women should be able to celebrate giving birth a lot more. I think it has been squeezed out of society and it is such an incredible journey to go on.

One Day Young
First edition

Photography by Jenny Lewis
Design and layout by Stefi Orazi Studio
Series design by breadcollective.co.uk

Copyright © Hoxton Mini Press 2015. All rights reserved
All photography © Jenny Lewis 2015. All rights reserved

A CIP catalogue record for this book is available from the British Library

One Day Young
ISBN: 978-0-9576998-8-5

One Day Young in Hackney
ISBN: 978-0-9576998-7-8

First published in the United Kingdom in 2015 by Hoxton Mini Press

No part of this publication may be reproduced, stored in a retrieval
system, or transmitted in any form or by any means, electronic,
mechanical, photocopying, recording or otherwise, without the prior
written permission of the copyright owner.

Printed and bound by RR Donnelley Asia

To order books, collector's editions and signed prints please go to
www.hoxtonminipress.com